Travelling

OXFORD
PRIMARY
art

Norman Binch

Oxford University Press 1994

Going for a walk

The simplest way to travel is to walk. These paintings are of people walking in their own neighbourhood.

? Can you tell where they are?

? What else can you tell from the paintings?

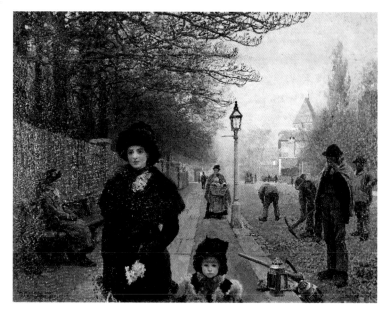

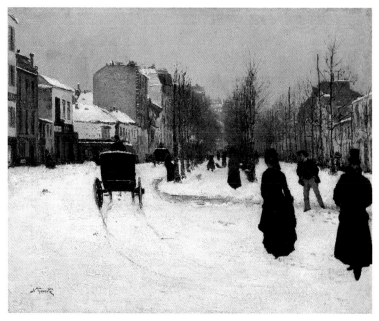

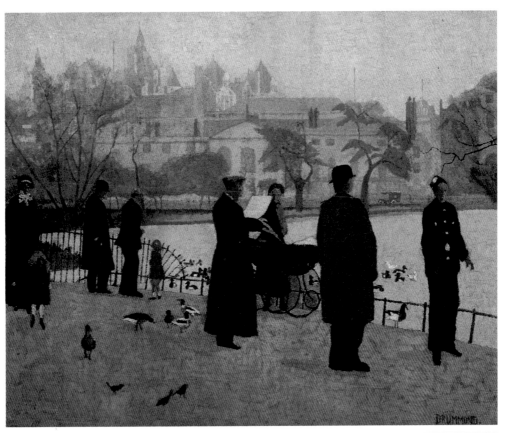

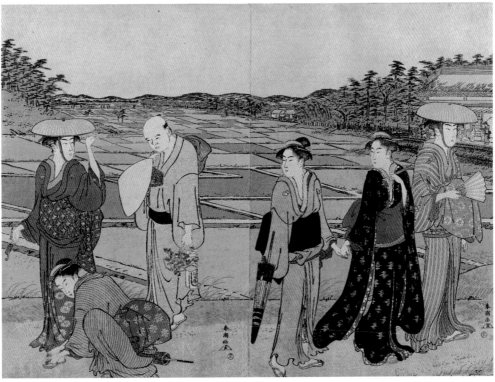

Transport in towns

In towns and cities around the world there are different kinds of *transport* in different countries. They are *designed* and made by people.

? Can you guess when and where these photographs were taken?

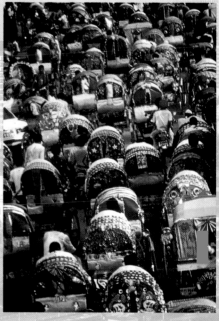

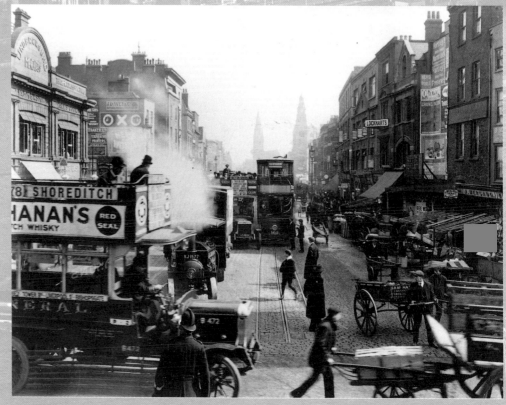

This is a 'trolley bus'. It runs on electricity. It is drawn so that you can see how it works.

? Can you see the wires above the bus?

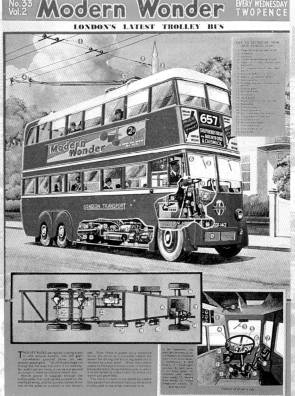

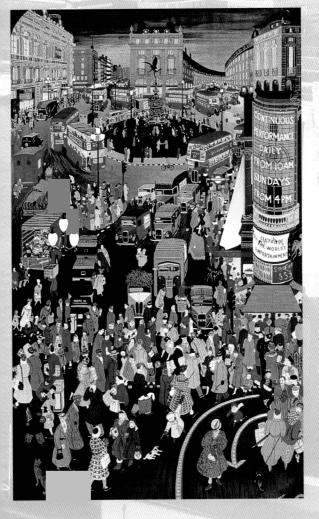

This is a *poster* showing buses in London's Piccadilly Circus in 1950.

The London Underground

These are posters advertising the London Underground. One is old and the other is modern.

 Can you tell which is which?

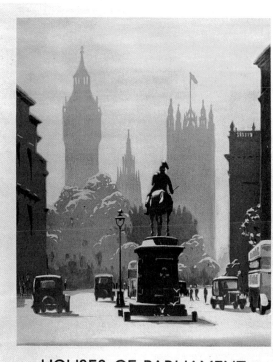

HOUSES OF PARLIAMENT

STATION - WESTMINSTER
OR BY BUS OR TRAM

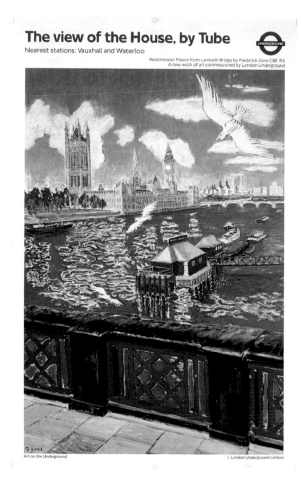

The view of the House, by Tube

Nearest stations: Vauxhall and Waterloo

Westminster Palace from Lambeth Bridge by Frederick Gore CBE, RA
A new work of art commissioned by London Underground

Art on the Underground

© London Underground Limited

These are pictures of the first trains to run on the railway to outer London over 100 years ago. Think of how trains have changed in design since then.

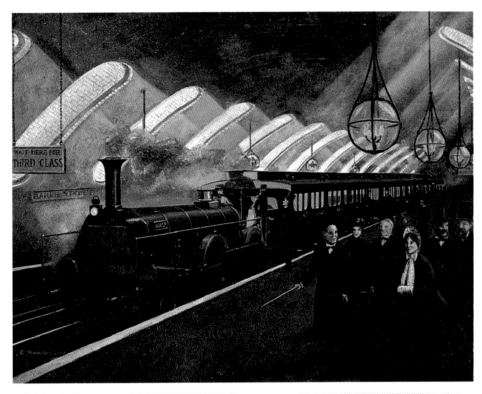

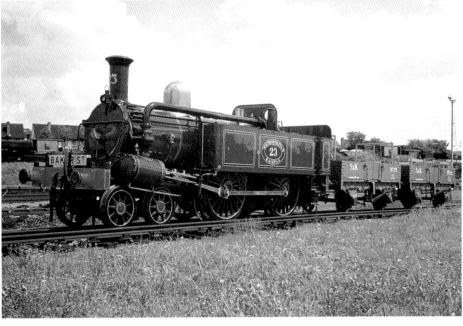

Ships and aeroplanes

These are also posters but they are *advertising* travel by ship. They are designed to make you want to travel on a ship.

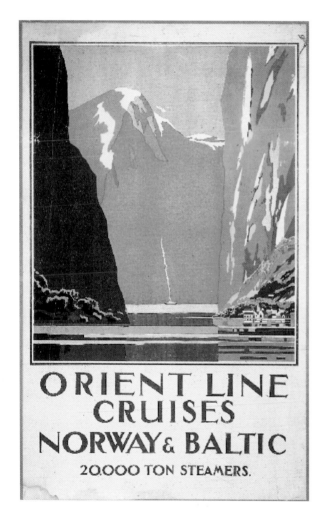

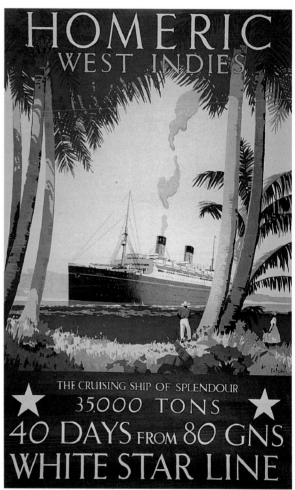

Aeroplanes and airports have changed a lot since these paintings were done.

This picture shows the airport for London at Croydon in 1920.

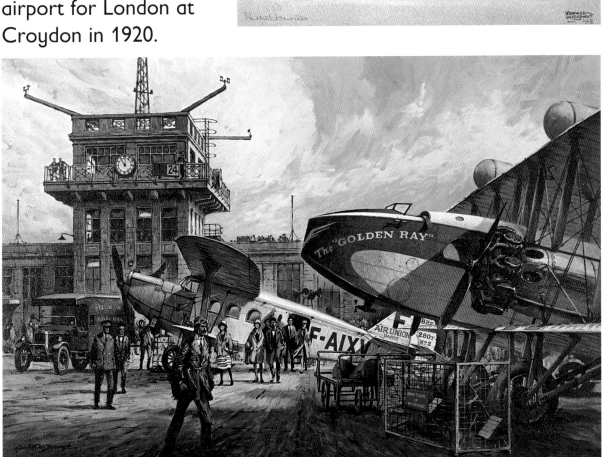

Aeroplanes, then and now

Aeroplanes were used for fighting in the
First World War. Now they are used to fly
people all over the world.

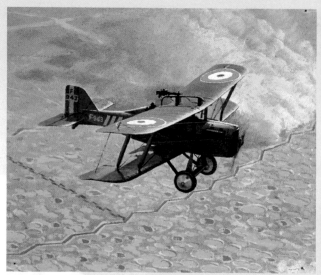

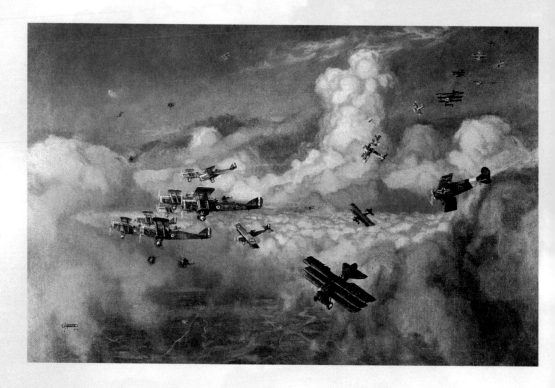

These are some of the designs used on aeroplane tail fins. They are like badges.

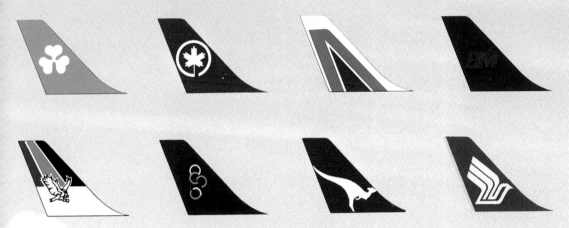

All aeroplanes are *designed*. This is a picture of Concord. It can fly very fast for long distances.

? Why do you think the *designers* have made it look like a bird?

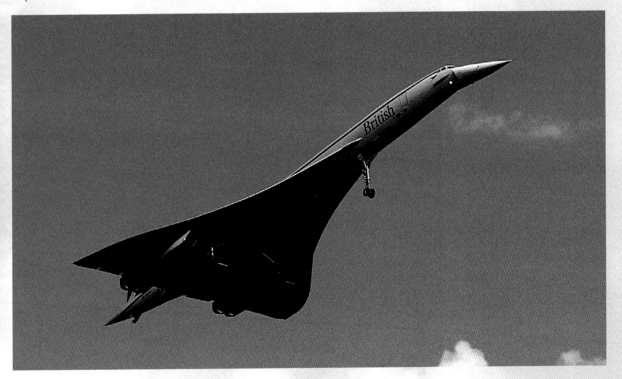

Boats and aeroplanes

Artists like to paint pictures of aeroplanes, boats, buses and trains. These paintings are very different. Artists have their own ideas about what is interesting.

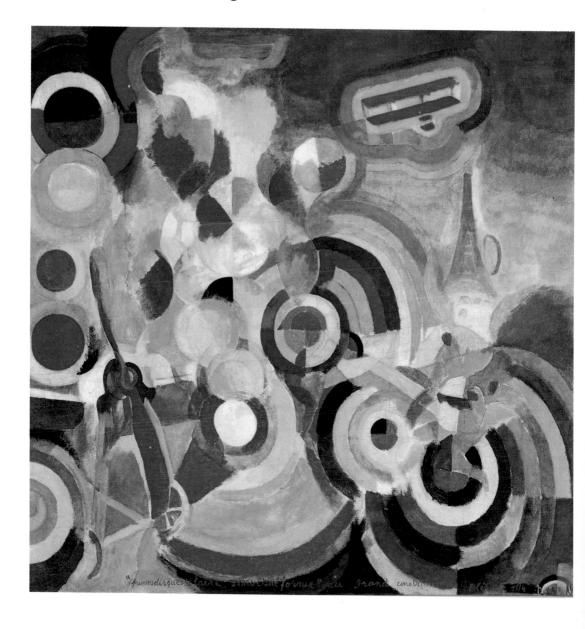

Can you guess which painting is the oldest?

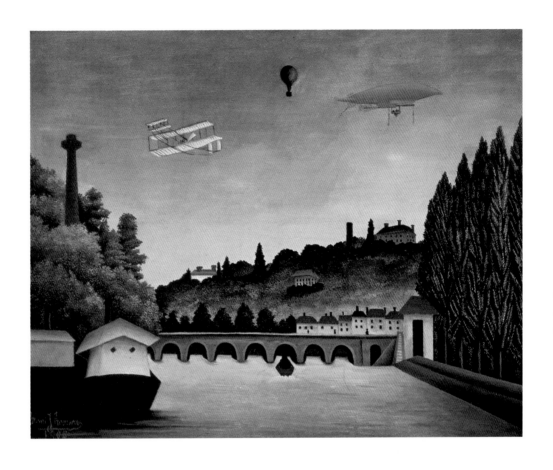

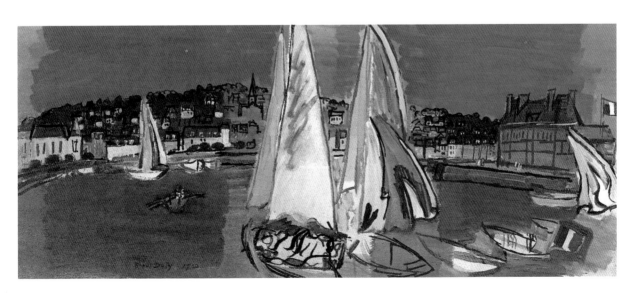

Road transport

This is a poster advertising a motorcycle.

 How is it different from a motorcycle of today?

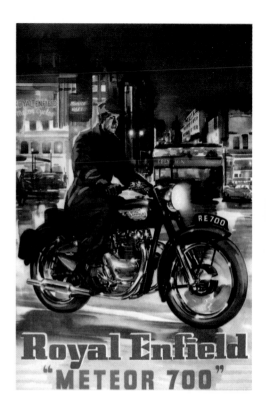

This is a drawing which shows how the car works.

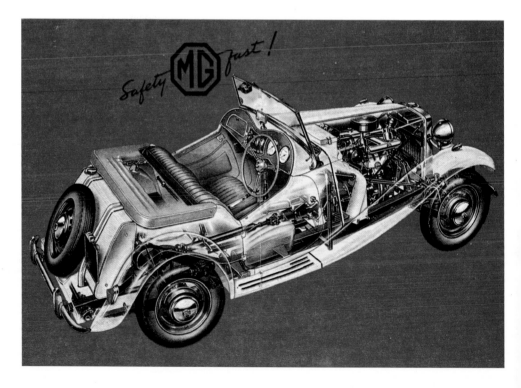

This rickshaw is very beautiful because it is decorated so well.

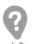 Can you guess where it is from?

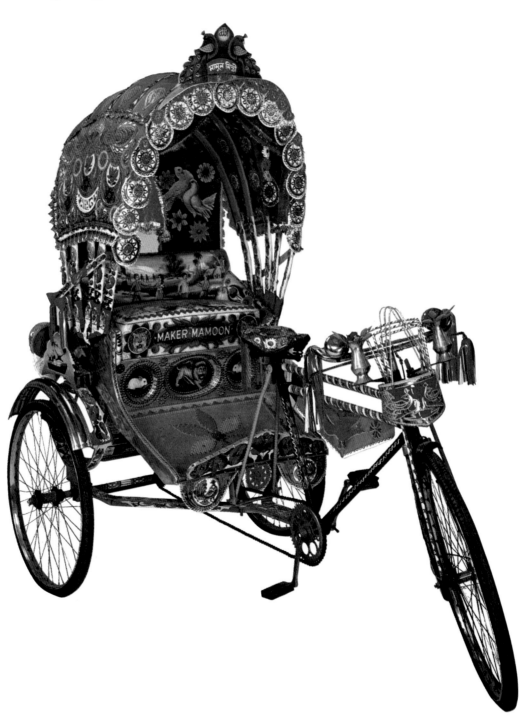

Kings

This painting is called 'The Journey of the Magi to Bethlehem'. It is about pilgrims pretending to make the journey of the three wise men who travelled to greet the birth of Jesus.

This is an illustration in an old book. It shows a holy man visiting a king. The king says 'Why have you not visited me for so long?' The holy man replies 'Because I would rather be asked why I had not come than why I had come.'

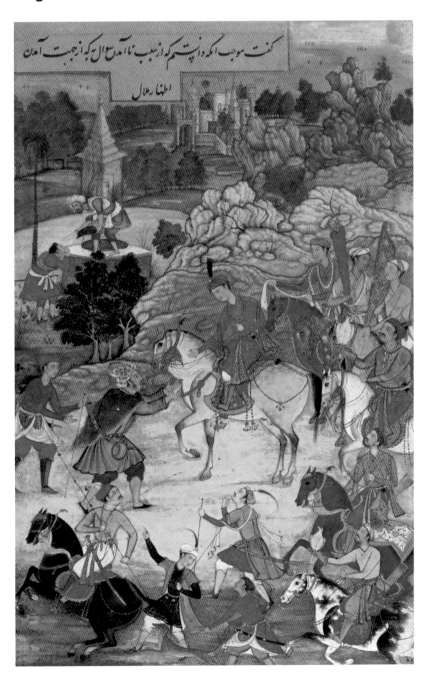

Travelling on horseback

These paintings are about people travelling on horseback for different reasons.

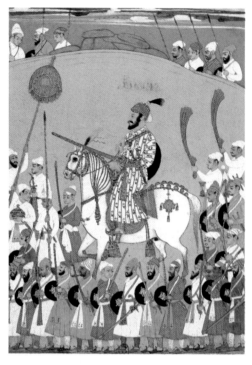

 Can you see why they are travelling?

Can you guess where they are?

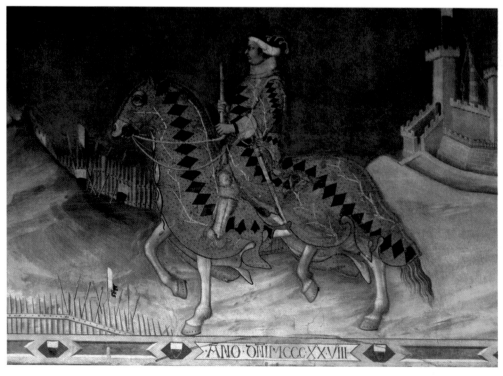

The paintings are from different countries.

 Can you guess which?

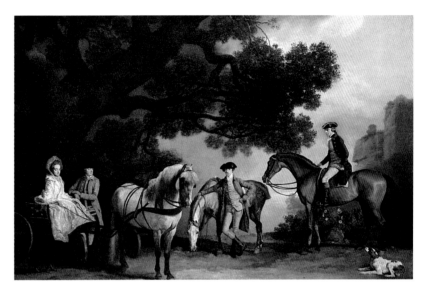

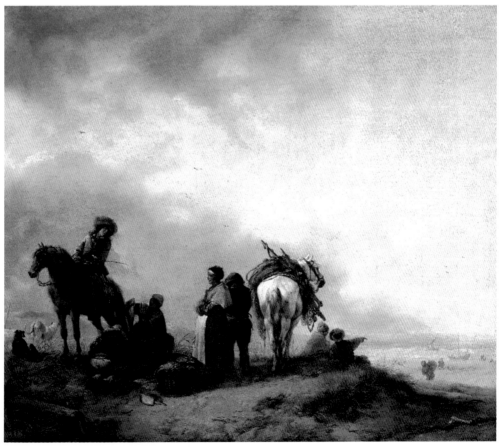

Holy journeys

This is an illustration of pilgrims on a journey to Mecca. It is a holy place and people make very long journeys to worship there.

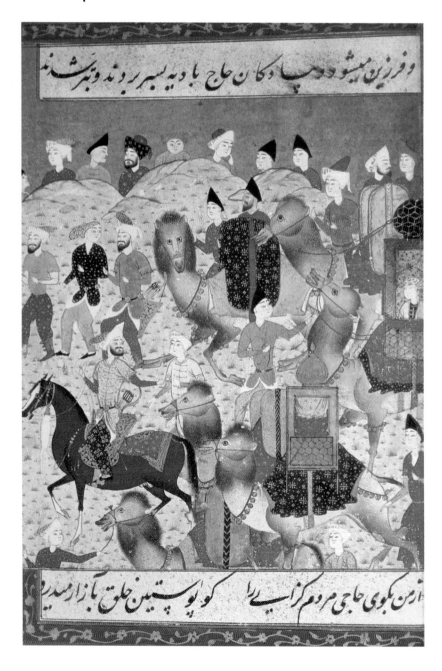

This is a painting of a Bible story. It is called 'The Flight Out of Egypt'.

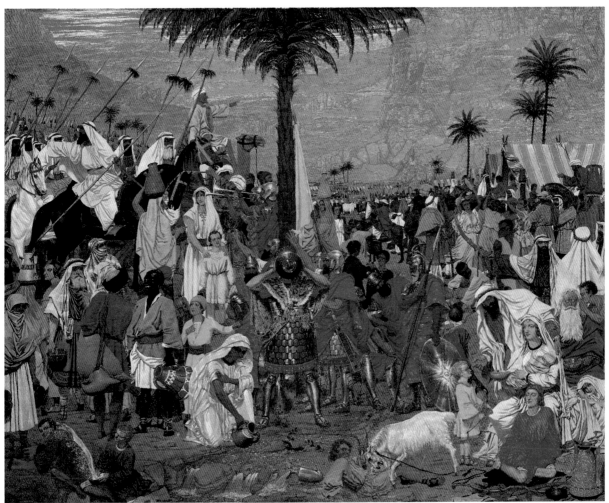

Things to do

Imagine that you are going on a journey. Make a painting of your imaginary journey.

Make up stories of things which happen on your imaginary journey and illustrate them.

Make a map of your journey to school. What can you see on your journey?

Collect pictures of all the different kinds of transport you can think of and stick them in a scrapbook.

Get an old skateboard and try to decorate it.

Make a model of an aeroplane, boat, train or car out of scrap materials.

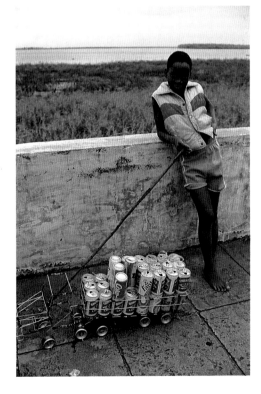

Words to remember

Transport
When you travel, you go by transport. It may be a car, or a horse, or a bicycle.

Design
Planning how to make things - and how to make them work better and look better

Poster
An advertisement for something which is stuck on places like walls, buses, and advertising boards

Advertising
Trying to sell something by showing people what it's like - in a poster or a newpaper, or on television

Oxford University Press, Walton Street, Oxford OX2 6DP
© Oxford University Press
All rights reserved
First published 1994
ISBN 0 19 834816 9

An acknowledgements list for the pictures in this book appears in the *Teacher's Resource Book*.

Printed in Hong Kong